TAO TE CHING FOR THE WEST

TAO TE CHING
FOR THE WEST

RICHARD DEGEN

HOHM PRESS

PRESCOTT, ARIZONA

1999

© 1999, Richard Degen

Cover design: Kim Johansen
Design: Greg Brown, Abalone Design Group, Sausalito, Calif.
Layout: Laurie Severy Graphic Design, Los Angeles, Calif.

Library of Congress Cataloging-in-Publication Data
Degen, Richard, 1938-

Tao te ching for the West / Richard Degen.
p. cm.

ISBN 0-934252-92-0 (alk. paper)
1. Lao-tzu. Tao te ching. I. Title
BL1900.L35D44 1999
299.51482--dc21 99-10148
 CIP

Hohm Press
P.O. Box 2501
Prescott, AZ 86302
800-381-2700
http://www.hohmpress.com

Printed in the U.S.A. on recycled, acid-free paper, using soy ink.

To my family

CONTENTS

INTRODUCTION

This book might best be viewed as an overhaul manual for troubled minds:

✦ Minds that are in an unrelenting battle with either nature, their culture, their surroundings or the people they must deal with each day;

✦ Minds that cannot understand why aggressive, take-no-prisoners behavior has not yielded better results;

✦ Minds that have not comprehended how our daily, repeated acts of selfishness deny us the ability to enjoy our lives;

✦ Minds that cannot trace the link between meaningless activity and lack of serenity;

✦ Minds that search for values but only find rules dispensed by spiritual leaders who profess to know the means for attaining happiness in the next life but leave their adherents bewildered as to how to face the realities of this life;

✦ Minds disturbed by philosophers and moralists who have made a shambles of their disciplines by drawing finer and finer distinctions over issues of less and less relevancy.

If you find yourself described somewhere above, you may wish to become familiar with a way of life that bypasses the happiness-depleting traps peoples of all ages have set for themselves and others. This system, which offers the prize of contentment gained though insight into how it is achieved and how it is lost, originated in a fresher time in human history. This was a time when nearly everyone, even people of distinction, still lived close to the land and saw more clearly than now the methods by which they, their neighbors and their leaders thrived or failed. It was also a time during which society more closely emulated the natural world, so that ways of acting and models for communities based upon fundamental, unchanging principles could be absorbed without the difficulty and distortion caused by subsequent cultural overlays.

The system is called Taoism, its origin is Chinese, its practice requires a twist of the Western mind, and this is the Taoist manual I wish I could have found when I first encountered this wisdom tradition many years ago.

Before examining Taoism in detail, consider first what it has to offer:

♦ Living easily and comfortably in the world is still possible in spite of your daily commute,

creditors, the need to make a living, your health, corruption on all fronts and the worries that loved ones invariably cause;

✦ There is an ancient system that advises how to flow with events rather than fight them;

✦ This system has proven itself to the extent that billions of people over the course of more than two millennia have practiced it, because it accords with the way humans want to be treated and the way they want to feel about themselves;

✦ It is free of all ritual;

✦ There are no requirements for repetitive mental or physical exercises;

✦ It is based on the lessons of everyday experience rather than theory;

✦ It does not require the possession of unusual intelligence or an advanced education;

✦ It is capable of comprehension even though it originated in a foreign culture, and there is no need to learn a second language;

✦ It is most effective when you most need it.

But where there are benefits, there are also costs.

✦ Without access to the proper text, literature on the subject can take years to decipher (thus the reason for this book);

✦ The system is not as well known in the West as it should be, consequently there are few people who can assist you or who will be available for the sharing of ideas;

✦ It requires the exercise of certain virtues (not necessarily the ones you encountered in elementary school), and hence the application of self-discipline;

✦ One of the virtues is the abandonment of attempts to control and dominate things, and loss of control is something people instinctively fear and avoid;

✦ It will not let you blame others for your problems, and thus puts itself at odds with many mental health systems and programs;

✦ Inappropriate behavior is not excused or ignored just because it is deemed routine or necessary within your family, organization or career field;

✦ It can be difficult to practice until you are willing to trust it, and trust comes slowly;

✦ Because of the foregoing, it is not going to usher in a New Age, and society will not be reformed.

APPROACHING THE *TAO TE CHING*

Taoism's principal text is the *Tao Te Ching*. The title can be viewed as meaning a book of the highest importance (Ching) concerning the Way (Tao), and the virtue, expressed as power, within an object in harmony with the Way (Te). The Taoism of the *Tao Te Ching* is commonly known as "Philosophical Taoism" (henceforth simply "Taoism") and is to be distinguished from "Religious Taoism" of a later age, which, because it differs so markedly from Taoism, is not treated in this book.

Though the *Tao Te Ching* is attributed to Lao Tzu, which could mean The Old Man or Master Lao, it is the work of more than one person and thus the term could also mean Ancient Masters. The use of the term was apparently merely a naming convention peculiar to a certain age, the purpose of which was to place the *Tao Te Ching* as a writing farther back in time than was actually the case, so that Taoism might compete more successfully with Confucianism.

As to the dating of the composition, it is speculated that the *Tao Te Ching* may have taken its final form about the middle of the third century before the birth of Christ, and certainly not later than that time.

While there is general agreement with respect to

Taoist principles, individual passages and ideas contained in the *Tao Te Ching* are subject to differing interpretations or pose other problems, for these reasons:

(1) The earliest Taoist writings were undoubtedly based on ancient sayings, orally passed on from generation to generation by various groups through sundry channels. As is well known, oral transmission often results in changes over time. A Western example would be a folk song of the American South that was transformed from "See the Lying Woman" to "Sea Lion Woman."

Any change could have been the occasion for a split in the oral tradition in the next generation, with one group clinging to the unchanged version or simply being unmindful of any change, while another group accepted the change.

(2) When writing became a means of transmission, some sayings were probably reduced to writing before others, thus there would probably have been an uneven progression in dissemination of Taoist thoughts.

(3) Although a single written version of a saying may have circulated, it is more likely that multiple written versions, like multiple oral versions, were in circulation simultaneously.

(4) It is possible that over a period of time a small number of compiled sets of written sayings came to be seen as the most authentic representations of Taoist ideas, and each such collection may have come to be known as the *Tao Te Ching* because of its similarity to other such anthologies. The result is that, while the various historic reproductions of the *Tao Te Ching* that are accessed by scholars today may be variations of one anthology, each may represent a separate major line of transmission.

(5) It is generally agreed that the oldest versions of the *Tao Te Ching* available to scholars are reproductions because, while the specific date and contents of the first anthology (or anthologies) may be unknown, none of the existing texts would be old enough to qualify as anything other than a reproduction. The question then arises as to whether any one of them might be an exact reproduction of an original anthology. While this is not impossible, they are probably all reproductions of an unknown number of prior reproductions, and every reproduction could have been corrupted by scribes through negligence or the insertion of their own ideas into the text as a reflection of personal values or as comments upon the issues of the day.

(6) Early commentaries upon these writings also

differ because the commentators did not share common texts, time periods and assumptions.

(7) The terse and archaic language itself presents many problems: Ancient Chinese texts employed no articles; discerning the tense of a verb could be difficult; nouns lacked number; a character might have numerous meanings; and the rudimentary punctuation that may have been used did not include guidelines for distinguishing sentences or phrases from one another.

(8) Due to the immense passage of time and cultural changes, the exact intended meanings of certain characters, phrases and metaphors within the *Tao Te Ching* remain unknown, and are an ongoing source of dispute among researchers.

(9) A literal translation of some ancient words or expressions would not make sense to a modern reader, and attempts on the part of translators to supply meaning have necessarily been personal.

These problems illustrate why every version of the *Tao Te Ching*, modern or otherwise, will be different. Thus, when contemporary scholarly translations are compared, you find there is variance in phrasing in every one of the eighty-one chapters, either as to what is expressed or how it is expressed. It fact, it

has been estimated that modern scholars are in disagreement as to meaning with respect to at least twenty percent of the text.

These problems also explain why the versions of the *Tao Te Ching* found on bookshelves are usually incomprehensible to the general reader, or at least not what was bargained for. Such versions are either too literal or too personal to have the kind of meaning needed to support the mental construction of a coherent set of principles that a normal person can use effectively. This is not to say such texts fail in what they attempt to achieve. They are marvelous, courageous undertakings and the integrity, wisdom, ingenuity and scholarship of their authors is evident. My point is simply that they are too obscure for the general reader. Few people are in a position to spend half a lifetime trying to extract meaning from them.

The carpenter or nurse who rushes home after work in order read of different ways of acting, different approaches to problem solving; the new employee who discovers the bureaucracy to be a mental institution run by the inmates; the middle-aged overachiever whose values suddenly seem absurd; the parent who sees a child veering

off on a path that will bring no good; the retiree who finally wants to make sense of it all: these people are just as entitled as anyone else to discover the Taoism of the *Tao Te Ching*.

What has been needed is a readable expression of Taoist principles that sets forth the core values of that system and rings true to the Western mind. *Tao Te Ching for the West* attempts to offer these things.

Throughout history, all cultures have taken a similar approach when adopting a foreign mode of thought. After the *Tao Te Ching* appeared, Indian Buddhism gradually migrated into China, and in the process Buddhist ideas were stripped down to their essential elements by the Chinese and defined using Taoist terms. Later, Japan took the Chinese form of Buddhism, modified it to fit the Japanese culture, and the result was Zen Buddhism. Western Europe gave believers affordable bibles printed in their own language, permitting fresh interpretations of the Old and New Testaments. Such efforts always share the same purpose: to put new ideas into the hands of the populace that are both relevant and comprehensible.

ABOUT THIS RENDITION

My version of the *Tao Te Ching* is a rendition, not a translation. I cannot read, write or speak Chinese, thus I did not use Chinese characters to extract meaning, but rather reviewed the phrasing and ideas of others found in English translations and commentaries on translations. After considering these works and my own professional and personal experiences, I created a Western version of the *Tao Te Ching* that is readable by all and fairly represents Taoism. In doing this, two problems predominated.

The first problem was the imprecision of ancient Chinese writing. Scholars know that the Chinese of the era that created the written *Tao Te Ching* were acutely aware of the limitations of their language, particularly their written language. While the need for precision in such traditional pre-writing endeavors as hunting, fishing, farming, exploration, construction, manufacturing, law, medicine, warfare, sailing and rituals resulted in a certain degree of oral clarity, there apparently was a significant gap in meaning when matters such as those encountered in the *Tao Te Ching* became the subject of writing.

The texts we possess, with their difficulties and ambiguities, would certainly be only dim reflections of the Taoist oral tradition that preceded and

accompanied these texts. Parties gathered for an oral presentation or discussion of Taoist teachings would surely have come away with a better understanding of Taoist principles than we can glean from a mere reading of the document known as the *Tao Te Ching*, and I have taken this into account and dealt with it in the rendition I offer.

The second problem was the need to extract meaning from the literalness of scholarly translations. Example: when I say to you, "I'll drop around to see you sometime," you might expect me to present myself some day, and something more than "seeing" is also expected. Further, you do not understand my "dropping around" will result in my descent in separate pieces, nor ready yourself for my impact with your roof. More significantly, depending on our relationship, you might understand me to mean that I am simply ending the conversation on a customary polite note and have no intention whatsoever of visiting you in the future. In other words, I am saying one thing but, under certain circumstances that cannot be described fully in words, people in our culture understand, without having learned it in a book, that I intend the opposite.

If this expression could be transported backward in time to someone living in China during the period

in which a writing called the *Tao Te Ching* started to circulate, would that person capture all the nuances and have the same cultural insights that you do?

The same issue arises in reverse when attempting to extract meaning from the *Tao Te Ching*. A Chinese word or expression used in that writing, if translated literally, might have no meaning today for the non-scholar, yet from an academic point of view (assuming the intent of the word or expression can actually be known in the first place), how far can the translator go in supplying meaning?

For someone offering a rendition intended for the general reader, the solution is to view various efforts made to handle this situation and either create a word or expression that conveys the sense of the chapter under consideration, or ignore the passage if overall meaning is not sacrificed. Whatever method is employed, the subtlety of one of the world's most elegant wisdom traditions must be preserved.

With such considerations in mind, the following procedures were utilized:

(1) Ancient words, plays on words, phrases, expressions, metaphors and "inside" references were either updated or eliminated if, when presented

literally, they would have no meaning for the general reader.

(2) Paraphrasing was devised and applied when a literal interpretation would cause confusion; to render intelligible any difficult or obscure concepts; to clarify terse or awkward phrasing; to avoid repetition. While I use paraphrasing more than scholars, even the most erudite translations, without exception, contain some paraphrasing or another method of clarifying the text, otherwise certain portions would simply remain unintelligible.

(3) Spare, terse phrases were expanded into complete thoughts when necessary for thorough understanding, as it was felt that it would not be helpful to re-transmit ideas that to the reader appear unfinished. There was also a need to avoid a type of "bumper sticker" presentation that upon first reading seems clever, but after reflection reveals only half-truths.

(4) References to occult beliefs, such as immortality gained through immunity from physical harm, were eliminated.

(5) Except where meaning would be sacrificed, the text was made gender-neutral.

(6) For better flow, readability and understanding, the traditional verse format (probably used, before writing, as a way of orally passing on Taoist concepts with the least chance of error) was abandoned in favor of the prose format.

To those who may take issue with this Introduction or with the version of the *Tao Te Ching* presented here, it should be understood that the task I undertook included two components: one was to be faithful to Taoist teachings and ideas; the second was to offer a guide that, to Westerners, feels legitimate and capable of being assimilated into everyday affairs.

It is my hope that, with access to a readable version of the *Tao Te Ching*, Westerners will be prompted to investigate its ideas more closely. If those ideas need slight modifications due to the nature of Western cultures, then so be it; Western Taoism is a psychological system in development, and if fine-tuning is necessary, that is something we should welcome and not resist.

The important point to understand is that we in the West have both the duty and the maturity to fold the principles of the *Tao Te Ching* into the commonplace practices of our cultures. This cannot happen while the *Tao Te Ching* is the captive of specialists in Asian philosophies. These scholars,

many of whose publications I consulted, served the cause of historical research exceedingly well through their interpretations and commentaries, and deserve our everlasting gratitude and respect. Now it is time for the Western non-specialist to have a chance to understand and embrace Taoist teachings.

In the development of Western Taoism there is certainly a place for the academic community, but that place should be populated not only with specialists in philosophy and language but also with political scientists, economists, biologists and psychologists. These professionals will offer insights that are simply not within the capabilities of scholars traditionally associated with Taoism, and will enhance everyone's understanding of the political, economic, biological and psychological premises underlying Western Taoist principles.

DEFINITIONS

"Virtue" is a term which, when used in the *Tao Te Ching*, can carry various meanings.

When an object is in harmony with the Way it has virtue, which is power. In humans, virtue is lost when selfishness prevails and harmony with the Way is lost.

The Way can only be sensed and embodied once again when it is allowed to enter us through self-denying and attention-avoiding practices such as yielding, caring and the lessening of cravings. These modes of acting have, in addition, been called virtues because, as elements of the Way, they generate power.

Then there is the Confucian type of virtue, which the *Tao Te Ching* criticized as not being real virtue. During the period when Taoist principles were being reduced to writing, the Confucian philosophy was its main rival. Confucians, it was thought, ignored substance and spontaneity and were guilty of moralizing, misplaced loyalties, undue emphasis upon form and ritual, and blind adherence to rules.

Taoists believed that one had to be dedicated to the avoidance of all pretense, affectation and intellectual dishonesty, and that when appropriate action was needed it had to be accomplished spontaneously, without a thought given to recognition or appreciation. They asserted that such "true virtue" was entirely different from Confucian virtue (as you read the text of the *Tao Te Ching* you will understand the type of virtue that is being described).

It would be wrong, however, to give the impression that the devotees of Taoism and Confucianism

were in conflict throughout the centuries merely because their concepts of virtue have been contrasted. The Chinese are, if anything, pragmatic, and have always been adept at reconciling differences and finding the "middle way." Both Taoism and Confucianism supplied something that the Chinese needed, and it would not have appeared odd to see a person practice Confucian values at work or in public and Taoist values in private.

As to Chinese rulers, they varied in terms of which philosophy was endorsed, but in general, and subject to exceptions, acted without prejudice to the system out of favor.

Public sentiment likewise shifted, depending on economic and social conditions. Usually, when conditions were stable and the people felt prosperous, Confucian values were preferred. In times of social unrest and economic insecurity, Taoism was favored. For some reason, after missing three meals in a row or watching an official confiscate your land because you cannot pay the required crop tax, Taoist principles are no longer deemed peculiar or quaint. It comes as no surprise to find that the *Tao Te Ching* first appeared as a writing during what the Chinese call "The Warring States Period," and that Taoism attained wider acceptance at that time.

Finally, observe in the *Tao Te Ching* how Taoist virtue is customarily associated with an individual's desirable personal qualities, and not with the individual whose causes you agree with in spite of that person's personal qualities. Causes normally come and go; the motives for supporting one versus another can be projected as entirely noble yet be less than admirable; the effort involved in support of a cause can be real or illusory. A Taoist is cautious and will expect trouble when the causes a person supports are deemed a suitable substitute for Taoist virtue in that person.

"A fit person" (which some texts call a holy person, a sage, a sane person or a person of reason) is one who is at one with the Way.

"The Way" is another Taoist term that has various meanings, depending on the context, and they derive from two different but related perceptions of the Way:

It can be understood in a non-metaphysical sense when referring to the physical (the workings of our mind-body and everyday environment) and the political (the relationship between the individual and society);

It can be understood in a metaphysical sense when referring to nature's origin, methods, qualities, or humankind's role in that system.

Thus, the Way can mean the way of flow and harmony with our surroundings and fellow creatures; naturalness; the proper path; the understanding of the proper path; the way of achieving without striving; the state of being where all contradictions are resolved; the way of nature; our place in nature; the natural order of things; the way things really are; the sum and substance of a thing. And it can mean, "That which preceded and still functions in the universe." By training and custom, Westerners will necessarily interpret this to mean God. The ancient Taoists were innocent of the West's concept of God, so if you make the substitution, note the following:

First, the Western God dispenses justice moment-to-moment to those who have strayed from or adhered to the requirements of a received and sacred text. Events in such a system are therefore not random but rather the result of divine intervention or guidance. Taoists recognize a superior power also, and believe that living in accord with the way this power manifests itself in the world will give us everything we need, but this power has no form; it is impersonal; it has no name; it never commands; it is voiceless; and it is always neutral.

Since there is no sacred book to look to, Taoists believe each of us must find a unique way to live in

harmony with what life brings; that all of us, like explorers of old, are "off the map" and on our own. Taoists further believe that this self-created harmony can only be achieved by living "in the moment" (which will be discussed later), in order to remain alert to signs of the Way and to remain flexible in the face of constant change.

Second, Taoists, like everyone, sometimes look for help in matters of importance, but the helpers are not spiritual intermediaries such as we find in the West in the form of ordained or consecrated holy men and women who claim special knowledge or spiritual powers as the result of a supernatural transmission.

Third, unlike Judeo-Christian, Islamic, Hindu, Native American and most other cultures, a creation myth was not an essential part of Taoist culture, and nature's origin, though it posed an important question, did not interest Taoists in the way it interested others.

What did interest Taoists deeply were the physical, psychological, political and family structures of the world they inhabited, plus the occult forces and powers they imagined were operating in that world.

The obsessive search for, and supposed manipulation of, occult energies would turn Taoism into a

rule-bound religion of little interest to Westerners. Taoism, however, becomes important to us due to the process used by the early Taoists to investigate societal harmony and human dignity issues, and the answers that resulted. This process involved penetrating and original observations of nature, culture and the human psyche. The answers gained from these observations led them to conclude that they had found the elements of a natural order, and they called this natural order "the Way." Being natural, and thus something whose origin was unknown and unknowable, they believed the Way existed in a cosmos that simply must always have been there. Science has since supplied more plausible theories with respect to the cosmos, but Taoist conceptions of the nature of society and the individual remain undiminished.

ATTRIBUTES OF TAOISM

It is most helpful, when encountering a new wisdom tradition, to have access to a summary of its most important principles or characteristics. For Taoism the list includes:

(1) Possession of a sense of wonder

(2) An appreciation of the way nature operates

(3) Humility as to what can be known and transmitted

(4) Acknowledgement of the limits of language

(5) Yielding

(6) Patience, non-interference and restraint

(7) Detachment

(8) Caring

(9) Avoidance of the need for recognition

(10) Action without action

(11) Elimination of cravings

(12) Dwelling in the present moment

(13) Trust in the system.

Each of the above items is considered in greater detail below.

(1) Possession of a sense of wonder. Enlightenment is preceded by wonder. While most Westerners are energized by a combination of fear, faith and guilt, wonder seems to be the switch that turns on facilities necessary for appreciating the subtleties of Taoism.

(2) An appreciation of the way nature operates. Taoism requires keen observation of the natural

world and human cultures that flow out of that world. Such observation should result in a realization that to challenge the way of nature and nature's creatures is not only futile and detrimental to any hope of contentment or harmony, but causes one to miss the beauty and opportunities that quietly and continually present themselves.

(3) Humility as to what can be known and transmitted. A quality can only produce meaning insofar as we know its opposite, but knowledge of its opposite poses an identical problem. In short, our understanding will usually consist of an approximation, a rough estimate and, above all, will be relative.

Difficult versus easy, ugly versus beautiful, useful versus useless: all reflect genetic inheritance, training and culture, and will differ among individuals and societies. Our perceptions of the qualities of things are therefore personal, may not represent absolute standards, and are usually only indirectly transferable to others, if at all.

(4) Acknowledgment of the limits of language. In spite of our best attempts, any language–even the jargon by which we make our living–is not as precise as we would like it to be. Further, we ask it to explain methods, concepts and entities that cannot

be known in the first place. Taoism then, except in matters of scientific inquiry, avoids attempts to use language to describe things that resist description, and views arguments and contention over such things as not only a waste of time but harmful.

(5) Yielding. An understanding of Taoist psychology includes awareness of the fact that the basic nature of the Way is the process of yielding. Those who wish to be at one with the Way make that the essential quality of their conduct.

Yielding does not mean abandoning excellence, nor retreating to a desert cave; to the contrary, it often entails using the most sophisticated tools a person can possess, and the most talented are often its best practitioners. What it does mean is that you harmonize your actions to the natural flow of events and try, whenever possible, to utilize those techniques and practices that cause the least resistance.

The creation of resistance impairs your mind and body and erects walls that leave others lacking in what you have to offer. That is why it is best to simply steer wisely and gently by utilizing your hard-earned knowledge of the natural flow of each event, accept whatever you cannot change, and allow the inexorable resolving process contained in every situation to do the heavy work. As the

Chinese would say, "Never push a river–it moves by itself."

This approach has the effect of reducing stress and allows humor to enter our lives, but that is not why it is recommended. Its justification rests on the fact that, over time, nothing else works. Nature, however mysterious, has its own logic, thus human cultures, which grow out of nature, must have their own logic, however mysterious. An individual's logic and personal trajectory through the world are ultimately tied to both. When you allow this subservience to function you become synchronized with that which is, you realize that everything is just as it must be, and the seemingly impossible becomes possible.

(6) Patience, non-interference and restraint. These practices are expressions of how one yields. They are all based on the premise that a process should be allowed to take its own course even though the urge to act is as compelling as the need to scratch an itch. Allowing a matter to develop along its own natural direction, and acting spontaneously only when the situation is ripe, produces the best solution.

(7) Detachment. This is another practice that falls under the general concept of yielding. In a

world that we know to be filled with uncertainty and unpredictability, we still stubbornly cling to things and others as if they will not change. This is often successful for a time, and this successful period sets us up for substantial injury when change occurs, as it inevitably will.

A few individuals eventually see love and hate, gain and loss, success and failure as self-created prisons. In that moment of realization, when the utter uselessness of struggle and conflict are acknowledged, they yield to the Way and are liberated. They still mostly do the things they always did, but with new motives, and their actions become both spontaneous and natural, not contrived or driven. Psychologically, they now view themselves as tourists, not prisoners. The chains still exist, but they are lighter and longer.

(8) Caring. Yielding is one of Taoism's prime virtues and caring is the other. But both are really two sides of the same coin: each protects against the things that would harm us, and each brings the things we need.

(9) Avoidance of the need for recognition. This virtue takes the actor out of the action and eliminates the resistance fostered by even the most generous of acts. While everyone can understand how

pride, vanity, boasting, pretension and ostentatious displays engender resistance and are therefore self-defeating, many are surprised to see virtuous acts produce the same result. Actually, no one should be surprised; when Mark Twain wrote that few things are harder to put up with than the annoyance of a good example, he was conveying a truth discovered long ago.

Since virtues such as leading by example, yielding and caring are such important Taoist qualities, it is important to include them in the inventory of acts that breed resentment when the need for recognition becomes a factor.

(10) Action without action. In any situation that presents a problem, Taoists attempt to utilize perfectly timed, effortless, minimal action–undertaken quietly and without regard for recognition–in that moment in which a solution arises naturally and spontaneously.

For those occasions that do not involve an obvious problem, but rather a minor but potentially troublesome situation that is too insignificant to be noticed by others, a different approach is applied. Being cognizant of the significance of small, weak things, and knowing that just a trivial effort directed against them can avoid an outcome that may become unmanageable if left untended, a Taoist might quietly,

and with little exertion, eliminate the problem at its earliest stage, thereby avoiding later conflict.

(11) Elimination of cravings. Every craving we feel is a barrier that keeps contentment just out of reach.

(12) Dwelling in the present moment. As an early Chinese sage wrote, "The Way is near, but people look for it in the distance. It is in easy things, but people look for it in difficult things." Similar to the notion that life is what happens while you are making other plans, do not expect to find the Way at some future career point, lifestyle change or conclusion of study: it must be sought every second—where you eat, work, play. This is not a trivial concept for two reasons:

First, one of the main causes of human discontent is a deep-seated feeling that a lifetime has been spent preparing for something that never happened. In such cases, the discontented misread the guideposts that nature abundantly places along the path: the arrows pointed toward the small, the everyday, the insignificant—not the large and weighty.

Second, even if one insists on goals, timetables and long-range planning, it is obvious that, for even partial success, such a course must be undertaken

with due regard to the innumerable small steps involved–steps that can easily be overlooked by not concentrating on the present moment.

(13) Trust in the system. Until the Taoist system has repeatedly shown itself to work for you, incorporating the foregoing elements of the Way into your daily life will mean the application of grit when a challenge is conventional, and the avoidance of a tragic mistake when the issue is momentous and panic approaches. Only gradually will you see that trust was well placed. You will then find serenity replaces grit, and a deep understanding replaces mere coping.

The above elements of the Way, when adopted, result in effectiveness, contentment and serenity. Put another way, when friction within oneself, with others and with the environment disappears, the mind clears and solutions form. This state of being should be the goal of everyone, from hermit to leader; learning how to achieve it is of particular importance to two groups:

Children constitute the first group. When children learn at an early age the virtues described in the *Tao Te Ching*, those virtues are practiced spontaneously, without thinking. The effectiveness that naturally results engenders the kind of trust in the system

that is so difficult to achieve when Taoism is first discovered later in life.

The second group includes those who manage people. We have all observed the competent, hard-charging type within this group who blusters and intimidates, rises to a certain level, and then loses momentum. People simply become tired of these tactics and either go around such persons, or retaliate with a vengeance.

FINDING OPPORTUNITY
EVERY MOMENT

You will recall that one of the listed attributes of Taoism was "dwelling in the present moment." That practice makes possible what can be called "finding opportunity every moment." The yin/yang-conscious Chinese of the *Tao Te Ching* would have attributed the finding of opportunity every moment to the power inherent in those who follow the Way. More specifically, however, they would have attributed the finding of opportunity every moment to the ability of a fit person to flow with the movement and unveiling of the Way through the positive/negative, good/bad, no action/action, being/nonbeing continuous interchange to which the things of the

world are subject. For instance, the Chinese image for "crisis" combines the characters that represent danger and opportunity. We are to understand from this that when an unwelcome event occurs you will be presented with the choice of taking one of two paths: the first will bring protracted harm or injury; the second will lead to an unexpected benefit or a new advantage.

In modern Western terms we might rephrase the Yin/Yang concept as follows: Nature is astonishingly complex—much more complex than previous generations could have imagined. Hence, no circumstance is presented as either wholly beneficial or wholly detrimental, but rather as a melding of the two. The result is that, with the correct attitude, it is possible to consciously extract from each moment that which is beneficial, and then carom, or daisy-chain from that opportunity to the next, moment-by-moment.

You can witness to your own satisfaction the finding of opportunity every moment. Simply note everything that bothers you in a given time frame. As each incident arises, stop and ask yourself: What is the upside? What would have been the result if this issue had not arisen and I had not learned from it? What would have been the result if this problem had not allowed me to see the

benefit that lay hidden within it?

Of course, constant changing of direction means there will be no predictability, but change is going to occur whether welcomed or not. Science has shown that not a single complex system permits long-term predictability, no matter what efforts are undertaken to monitor such a system.

The reason for this phenomenon is that, in such a non-linear system, an indeterminate number of inconceivably small effects may produce an indeterminate number of greater effects, and this cycle may be repeated an indeterminate number of times, making it impossible to forecast a likely result. To further compound matters, we live in not one, but a web of complex systems, each impacting the rest. Thus, the flapping of a butterfly's wings in South America can be insignificant, or the trigger that causes a tornado in Oklahoma.

Your own experience confirms this lack of predictability: An inappropriate word, a chance meeting, a glance, a momentary lapse in concentration can all spell a different future for you and possibly many others.

Since unpredictability is a fact of life, the challenge that Taoism so successfully meets is to tell us how

to deal with it to our advantage so as to make unpredictability an opportunity and not a liability. In short, it raises the concepts of flexibility and spontaneity to a new level. Though the words are from another culture, a Taoist would understand the fourteenth-century anonymous Samurai who wrote, "I have no strategy—I make 'unshadowed by thought' my strategy."

Extracting opportunity from every moment could easily turn into a selfish or antisocial exercise if there were no boundaries, thus Taoism uses nature as a template for the establishment of ground rules. This approach would seem subject to criticism, since it appears to open the door to a great deal of subjectivity as to what is in accord with nature (note, for instance, the controversies surrounding both the "Natural Law" and "Social Darwinism" schools of philosophy). Writer Anatole France (1844-1924) summarized this criticism as follows: "It is almost impossible systematically to constitute a natural moral law. Nature has no principles. She furnishes us with no reason to believe that human life is to be respected. Nature, in her indifference, makes no distinction between good and evil."

The problem with such a statement is that it

does not fully describe the world we inhabit, therefore it is of limited usefulness. The world our ancestors dwelt in and passed on to us, and which we will pass on to those who follow, consists of more than unsparing physical laws and predator/prey relationships. It is also one of elaborate human cultures, and they are just as much a part of nature and the concept of naturalness as the tree in your yard or the ants in your kitchen.

These cultures embody, as humankind's principles and values, our virtues, vices, codes, social patterns and laws. In other words, nature leaves tracks: it acts through its creatures, and we have a good record as to the human kind. Thousands of years of human cultural experience have supplied the wisest of observers with clues as to how human cultures—themselves products of nature—thrive or fail.

We know, for example, that successful cultures—cultures that capture the imagination and respect of most thoughtful observers—have all developed workabl mechanisms for dealing with selfish behavior. In the West, the mechanism generally employed to deal with selfish behavior has been the enforcement of what are believed to be God-mandated moral laws. In Taoist-type cultures, the mechanism has been the teaching of both the need for harmony

among citizens and the ways through which harmony is achieved by the group and the individual.

Successful cultures have also excelled at fostering healthy, engaged, productive minds, supportive families, and political structures that encourage the foregoing. Moreover, certain successful cultures have recognized that some thing, at some time, gave us/the flowers/the birds a home capable of providing all that is needed if we practice patience and do not destroy it.

Taoists derive their values from what they deem to be the best of these cultures, supplemented by observation of the rest of the natural world.

EAST VS. WEST

While characteristics I assign to the East or West are certainly not unknown to the other, and speaking in generalities is an invitation to criticism, differences in kind or degree do exist in spite of much that is shared. In studying the *Tao Te Ching*, you will immediately notice thought patterns that are not a common part of the Western approach to life:

(1) Eastern wisdom traditions tend to view a

thing as part of a cycle, thus the study of cycles and the placement of each phenomenon within the correct cycle are considered fundamental to understanding. Western cultures tend to see processes as heading in a generally linear path toward a final resolution.

(2) Taoism teaches that one can intuitively perceive the Way if the virtues described throughout the *Tao Te Ching* are practiced. The result is a sense of harmony with existence. To a Westerner, the Taoist virtues that lead to insight seem counter-intuitive (e.g., yielding; non-argument; non-forcing; non-craving).

(3) It was previously noted that, in any situation that presents a problem, Taoists attempt to utilize perfectly timed, effortless, minimal action–undertaken quietly and without regard for recognition–in that moment in which a solution arises naturally and spontaneously. Many Westerners are not comfortable with this approach, and traditionally act somewhat impulsively, unaware of any other means to achieve an end.

(4) Taoism teaches that in order to endure and prevail in the uncertain environment we all live in, one must avoid attempts to modify things through aggressive, direct action. Situations should be managed in a non-hostile manner, and change should come about in a natural, often indirect, fashion.

This takes time plus a great deal of patience and discipline, but in the end usually produces fine results.

The West generally scorns this approach and tends to treat the world and the creatures in it as direct challenges, to be conquered and prevailed upon. This often leads to short-term success and long-term failure.

(5) Taoists accept and even relish the use of fuzzy concepts such as the dependency and legitimacy of opposites. Traditionally, and in spite of evidence that the brain functions in such a manner, Westerners have rejected approaches that yield answers such as Both, Probably, Usually–rather than Yes or No.

(6) Followers of Western religions take pride in claiming they are merely "in" the world (temporarily, and even then not a part of its vices), not "of" the world (permanently, with all its vices), and believe that, upon death, they leave the system and join God, who is also outside the system.

The implications of such a view must, it would seem, affect every aspect of Western cultures, as the earth is not seen as our home but rather as an evil detour on the way to salvation. To a Taoist, all things are permanently integrated into an unpredictable but nurturing existence.

(7) Taoists believe that the solutions to people's problems are not based in theology or abstract philosophy but in sound social and political relationships founded on a useful, time-tested way of life (it has been said that all of Chinese philosophy is essentially the study of how people can best be helped to live together in harmony and good order). Thus, the Taoist sense of what a Westerner would call "sin" is not that of a theological breach but rather self-absorption or selfishness practiced by a calculating person who is adept at taking advantage of the innocence or weaknesses of others.

Since they believe that selfishness is the cause of disharmony and strife in society, Taoists place it at the top of the list of acts that should be avoided. On the other hand, they share with many Westerners (who are less bothered by selfishness) the view that taking the next step, and forcing someone to act in an unselfish manner, inhibits very desirable-qualities such as creativity and choice, and can be counter-productive. Experience shows that anything other than a minimal amount of coercion gives rise to a multitude of vague and complex rules. By their very nature, such rules cannot be enforced in a uniform manner, and the result is bitterness and confusion.

(8) To Taoists, a way of life that does not permit and encourage the feeling of harmony with nature and our surroundings is defective. To a Westerner, the harmony experience is less relevant to the task of justifying a doctrine, especially since the way of nature itself is often considered to be irrelevant.

A Taoist would retort by saying that no matter what approach is taken, the approach is for use by humans, not machines, and that humans need to feel in tune with, and in fact be in accord with, their surroundings. A Westerner might reply that if the doctrine is carefully designed, humans can be made to work within it whether they feel it is good for them or not.

(9) When, as is often the case, there is insufficient information and a decision must be made, Taoists fall back upon intuition or instinct to discern the Way. This is an effort to deal with the whole person, and not merely "dry reason" independent of "gut feeling" cues. Thus it can be easily argued that Taoism is the truly rational system and that Western philosophy, in its attempt to rely upon logic divorced from feeling, is the irrational system.

(10) It has been said that Taoism is based upon *a priori* reasoning, in that meaning is derived by deductively reasoning from what one determines

to be self-evident propositions (e.g., truth as known without examination or analysis). This is contrasted with Western, *a posteriori* reasoning, where meaning is derived by inductively drawing conclusions based upon observed facts.

This analysis is incorrect. Taoism stresses the learning of the Way through experience and unbiased, informed observation of the self, society and nature, untainted by dogma or ritual. It depends upon observation to an even greater extent than Western "logic divorced from experience" philosophies do.

This means that a degree of right/wrong analysis has its place in Taoist psychology, as it does in all wisdom systems, since it is an appropriate device for evaluation of the human condition and for scientific research. On the other hand, Taoists know it can easily be abused when the user loses sight of the limits nature imposes upon human language, knowledge and reason. Harsh judgments must be tempered by compassion.

(11) Taoist cultures are the products of a pre-urban, agrarian way of life, later tuned to meet the demands and stresses of urbanization, competing cultures, centralized government, large-scale wars, mass famine, organized crime and political chaos (one author has described the era that saw the emergence of the

Tao Te Ching as similar to that of the French Revolution). During all of this, however, these cultures never forgot the way of nature, nor the need to live in harmony with it.

Western cultures, though they share the same roots and confronted similar forces, long ago irrevocably cut their ties to nature, favoring instead theological, commercial or idealized models in which humanity lifts itself by its own bootstraps above the rest of nature and assumes an attitude of unaccountability to any population group or part of nature that does not fit such models.

Thus, and in spite of protestations to the contrary, the West sits on the three-legged stool of big government, big business and whatever religion can accommodate these forces. It seems to have adopted the disturbing aspects of Confucianism that were assailed in the *Tao Te Ching*: the dominance of propriety over genuine emotion; display and style over substance; dry learning over informed feelings; rules over caring; doctrine over wisdom.

HOW TO USE THIS BOOK

The usual practice is to read a book and then go
to another, never to view the prior book again.
That is not the way to make full use of this book.
Keep it handy, master its lessons and use it to
refresh your mind. Blocking off a certain time period
each day for study is helpful; for instance, reading a
few chapters before sleep is an easily acquired
habit.

Even after you feel comfortable with the text,
great patience will be required. In spite of the fact
that Taoism consists of only a small number of
core ideas, you will not immediately be capable of
utilizing them with any kind of regularity. During
a stressful situation, and when it is most needed,
the Taoist approach may be unavailable for recall
or may seem inadequate, and what follows, of
course, is a non-Taoist response—the response you
were probably taught in the family, at school, at
work, during play.

The best advice one can give, therefore, is to
ease into this new way of acting. Your psyche
needs time to establish fundamentally different
behavior patterns. Since these patterns represent
our knee-jerk reactions to all challenges, and are

firmly embedded in the lower edge of consciousness, change is going to entail a lengthy struggle.

This struggle involves not only the implantation of new values, but the reconciliation of two conflicting but necessary pursuits: how to function easily and well in the everyday world but at the same time become enlightened in the sense that the whole is seen and not just the parts. Such a rapprochement will exclude mindless passivity and physical withdrawal from the world, because Taoism is not about those things. It will, on the other hand, include the Taoist methods of dealing effectively but serenely with all the daily events one may encounter, both superficial and serious.

You can now see why you need not be discouraged when, at first, your conduct does not follow your good intentions and why, in attempting to make the Taoist approach instinctive, there will be many failures and more than one act of questioning the existence of the Way. You can, however, shorten this learning period.

First, read each of the eighty-one chapters of the *Tao Te Ching* repeatedly. Second, if you revert to a non-Taoist approach when dealing with a difficulty and the result is unsatisfactory, set aside time for contemplation and self-examination to determine

what the Taoist solution would have been. The answer may not be obvious, but there is always a solution and this is a necessary exercise. Third, do not let introspection be a substitute for engagement. As one wit said, "Good judgment comes from experience, and experience comes from bad judgment." If you are serious about self-change, speculation about implementation must be accompanied by constant and determined efforts in your daily activities to actually live by the principles of Taoism. In the end, behavior is modified not through mere study and meditation but through involvement and experience.

SUMMARY

The best expression of the significance of the *Tao Te Ching* can be found in Professor Huston Smith's fine book, *The World's Religions* (Harper San Francisco, 1991, p. 218):

There are books whose first reading casts a spell that is never quite undone, the reason being that they speak to the deepest "me" in the reader. For all who quicken at the thought that anywhere, at every time, the Tao is within us, the *Tao Te Ching* is such a book. Mostly is has been so for the Chinese, but an American

poet can equally find it "the straightest, most logical explanation as yet advanced for the continuance of life, the most logical use yet advised for enjoying it." Though obviously never practiced to perfection, its lessons of simplicity, openness, and wisdom have been for millions of Chinese a joyful guide.

TAO TE CHING

HOHM PRESS publishes works in the fields of health, personal transformation, poetry, fine spiritual literature and children's books. If this book was of interest to you, we will be happy to send you a catalog.

Name _____

Street or box number _____

City _____

State _____ Zip _____

☐ PLEASE DO NOT PUT MY NAME ON YOUR MAILING LIST.

HOHM PRESS
P.O. Box 2501
Prescott, Arizona 86302

1

There are things that cannot be described by or understood through language. A complete description and understanding of the purpose and operation of the Way is beyond the power of language.

Whether you try to reason your way through life or act through emotion, the words associated with each path can be traps, not bridges, because they hide what is common to each: the presence of mystery.

2

When virtue is flaunted you can be assured it is that virtue's opposite you are witnessing. Everything has an opposite and is defined in relation to it.

Interfering is easy; allowing things to take their course requires restraint. Lecturing about virtue is easy; leading only by example requires patience. Letting others know of your kindness is easy; assisting without recognition requires humility.

3

By not favoring one over another a leader prevents strife. By avoiding shortages a leader eliminates the need for people to steal. By not displaying things people crave a leader causes people to more easily accept what they have, and life is then less chaotic.

People can be taught to reduce their cravings by learning the difference between what is essential and what is superficial, thus starting the process of virtue-building. This approach thwarts those who would exploit others through preying upon their cravings.

When you go through life without grasping, everything is accomplished.

4

The Way is unexplainable yet always available and useful. Trust it for there is no sharpness to cause pain, no trap to become ensnared in, no light that will blind. It simply lies waiting, like a tool in the dust, ready to serve.

Its origin is unknowable, but it preceded the things we know.

5

The earth and the firmament go their own way irrespective of the human way; they are generous only to those who flow with them.

Understanding this, the fit person will accept as natural whatever comes, whether it is initially considered good or bad, and will weigh all human rules against this higher order.

To be ready for whatever life brings be silent, be alert and avoid extremes.

6

The Way, immortal motherhood that it is,
continually nourishes anyone who cares to use it.

7

Why do the earth and the firmament persist?
They persist because they do not worry about
themselves.

Make your own interests subservient to the
interests of others. When you offer to others the
things they need, and not what you need, they will
draw you to the forefront, satisfying everyone.

8

Model all of your actions after those of water,
which provides nourishment without controversy
and which can be found in places people avoid.
This is what makes water similar to the Way.

Live simply and close to the soil. Dwell upon
the essentials, not the frivolous. Serve the interests
of others. Keep your promises. In leading, use
restraint. In making a living, fully develop your
skills. And always time your actions with awareness
of the way things are and not as you might like
them to be.

The reward for such a life is that you are not
looked upon as the cause of controversy, and are
free of blame.

9

A vessel loses its contents when overfilled. A cutting edge becomes weaker the more it is sharpened.

An attempt to control too much invites failure and leaves you open to danger. Control is most dangerous when it represents the fusion of pride, wealth and power–a combination guaranteed to produce tragedy.

The fit person understands the need for detachment, which is a characteristic of the Way.

10

Can you align your mind and emotions with the Way? Can you become as spontaneous and tender as a child? Can you eliminate all non-essentials, see to the core of things, and attain understanding?

Can you, when leading, know what to ignore? Can you withhold and grant with the concern a mother has for a child? Can you set the right course without striving?

Assist, but do not try to control; lead, but not by coercion. These practices bestow hidden power.

11

Spokes unite at nothingness and the result is a wheel. Clay is rounded around nothingness and the result is a container. A wall is framed around nothingness and the result is a door or a window.

Take note of the usefulness of the unexpressed and the undisplayed.

12

Eyes can be overwhelmed by light, ears can be overwhelmed by sound, taste can be overwhelmed by food, and the mind can be overwhelmed by cravings.

A fit person's moderation, and detachment from a life of excess, allow self-examination and insight.

13

Worry about being disgraced can debilitate a person who wants to appear successful. Why disgrace? Because of feelings of isolation and vulnerability. Why such feelings? Because there is too much thought of self and not enough of the interests of others. Regardless of status, when you act only for the welfare of others you are invulnerable.

A person who would lead will thrive and can be trusted if that person has no self and therefore does not worry.

14

Complete understanding of the Way is beyond the power of mere senses such as sight, sound and touch, so we simply speak of the original oneness, without really knowing what that means.

We are incapable of conceiving the beginning or end of things, cannot describe how each thing depends upon all others, and have difficulty accepting constant change.

But remembering how the ancient ones followed the Way will add to our understanding.

15

The ancients who understood the Way were subtle, introspective, profound and acute, all of which resulted in an inscrutability that places limits on our knowledge of them. All we can do is describe their characteristics.

They were cautious, like people crossing a body of water in winter; attentive, like people sensing a hazard; constrained, like visitors; yielding, like ice giving way to water; plain, like a common scrap of wood; receptive, like a valley sitting below mountains; impenetrable, like dark water.

How many of you can do nothing until clarity of mind allows spontaneous action? Who can then act without appearing to act? The fit person is calm while others seek and crave, and therefore avoids undue wear and fatigue.

16

Quiet your mind and watch living things grow and die; you will then realize that death means rest and that death makes room for life. Knowledge of this cycle permits perception of the way things are.

It is ignorance to acknowledge only your life and not your death, for this gives rise to the frustration of unlimited cravings.

By expanding your outlook and seeing beyond self and the fate of your body you will be able to sense the Way, unimpeded by distractions.

17

The Way can be likened to the rule of a wise leader whose followers thrive without knowing they are guided. The Way is not like that of a ruler whose subjects feel the need to render homage, nor is the Way like that of a ruler who causes apprehension or, worse yet, hatred.

If you trust in the Way, your trust will be rewarded. If you trust in people to do the right thing and let them alone, your trust will be rewarded.

Be like the wise leader who understands the Way: speak little and act spontaneously, without contrivance. Those who benefit will think they were responsible.

18

When the Way is not followed, rules, artificial distinctions and rituals take the place of decency; displays of affection substitute for family harmony; pledges of loyalty are demanded as discord spreads throughout the country.

19

Stop displaying your piety and circumspection; everyone will be relieved. Stop telling people what is good for them through laws; people can then find their own goodness. Stop using your cleverness to take what others want; they will then stop coveting you.

These things do not create a civilized life but rather the pretense of such a life.

Just live simply, put yourself at the service of others, and be aware of how craving for things or for control dulls you to knowledge of the Way.

20

Avoid scholarship that makes endless distinctions instead of solving people's problems. In this regard, before making an issue out of something, ask yourself if it is substantial enough to even bother with and, if so, whether the opposite view might be equally valid. Follow your instincts, not rigid rules imposed by others.

People seek the good life of feasting and traveling but I am meditative, like someone waiting for a message. To those who own too much or intellectualize too much, and therefore believe they have their lives in order, I give the impression of being untutored, unsophisticated and without purpose.

I find sustenance not in superficial things but in the things that matter.

21

A fit person follows only the Way.

Yes, the Way is shadowy and obscure, but the fit understand that it has always been a haven because of its nature: constant care for everything under its domain.

22

If you have lost the Way you can find it. If you are overcome you can rebound. If you lack you can be made whole. If you are weary you can be invigorated. But if your cravings have taken control of your life, these things are not possible.

Shape yourself in the mold of the fit person, who does not self-promote and thus grows in insight; does not boast and becomes renowned; is free of goals and is therefore not impeded by others; does not argue and is brought into the confidence of others.

The ancients were right: you can find the Way if you are lost.

23

Say what must be said and then move on. Let nature be your guide: a rainstorm sweeps through and then there is calm; winds blow hard and then there is stillness. Why should you be an exception?

Those who seek the Way and patiently practice virtuous acts, such as reticence, will eventually find it. Those who give up in their search for the Way place themselves out of its reach, and become lost.

If you do not trust in the Way, you will not find it.

24

Just as you invite a fall by standing on your toes, offering new ideas or acting in ways others do not act will be unproductive if you are then seen as vain, boasting, a know-it-all or silly.

A fit person is extremely careful under such circumstances. Even a hint of inappropriate conduct will cause revulsion in others, similar to having eaten too much.

25

Before the universe existed there was something astounding and self-contained which, while it has not itself changed, has mothered everything else. If forced to give it a name I would simply call it Great, but it would still remain unknown.

This entity manifests itself as the Way, and when things die or disappear they return home. Backward and forward–through humans, the earth, the universe, the Way–that which is natural flows.

26

Lightness yields to heaviness; activity yields to attentive inactivity.

Insight and not shallowness, quietude and not pointless activity, are two virtues that make possible a serene mind capable of sensing the Way. Such a mind can then handle the allure of glamour and the distraction of the unfamiliar.

Leaders who do not understand these things have nothing to fall back on in times of confusion, and soon become followers.

27

A fit person acts unobtrusively and does not leave tracks by demanding recognition; articulates advice clearly and does not cause confusion; renders to all what is due them so that no one feels cheated; locks no one out of knowledge of the Way so none can claim to have been denied; binds no one through imposition of dogma yet secures minds through good example.

The fit thus have a duty to other people, and to other things, to do what is best for them. Nothing can be abandoned, and in spite of any other awareness they may possess, those who would deem themselves fit lack true comprehension of the way things are if they do not understand this fact.

28

A fit person possesses the fearlessness of a male but, more importantly, the caring qualities and inner strength of a female, and thus becomes helpful to all that need assistance, just as a stream nourishes everything along its banks. By offering yourself to others you never lose the Way, and become as simple as a child.

A fit person knows how to shine while remaining in the shadows, and becomes a model for others. Such a person may be esteemed but practices humbleness, like a valley lying beneath great mountains.

These virtues allow you to flow with ease and suppleness through life and make you useful to others, who then allow you to lead them.

29

Experience confirms that when a person disregards the Way and acts as if decency was a quality yet to be discovered, that person does not succeed. All that person does, before succumbing, is to upset the balance temporarily and create insurmountable resistance. The Way represents perfection and cannot be improved upon.

Conduct of the unfit seems always to be inappropriate and unnatural: either disdainful or cringing; either hotheaded or too deliberate; either domineering or fragile; either self-satisfied or sheepish.

The fit person avoids extremes.

30

A fit person will advise a leader that coercion of whatever kind causes an equal amount of resistance, and that only those of true strength have the ability to use restraint and know what to overlook.

If action must be taken then be firm, but act in the spirit of humility, moderation and reconciliation. Excess effort may bring short-term results but always long-term grief.

31

Devices that bring another to submission are best left unused, for they spring back upon their user; a fit person will counsel all to avoid them. People ordinarily understand this but tend to forget it when incensed.

Never look upon such devices as objects of beauty because when you do you will find them enjoyable and when you find them enjoyable you will find their use enjoyable. This you will regret.

Measure the use of coercion carefully, exercise it only when necessary, and make reconciliation a priority. One of the ways by which the use of excessive coercion can be confirmed is when you celebrate the affliction you have caused. In such event, you can be assured you will eventually bear the consequences of your lack of prudence. Treat such a victory as a funeral.

32

Because the Way acts with only the lightest touch, it is not possible to create a complete set of rules that will consistently explain how it works and how one can conform to it. But that does not mean it can be ignored, for it is the source of all harmony.

If people who regulate behavior and thoughts would mimic the Way, they would cease controlling and order would spontaneously follow. Instead, they think they can create, where others have failed, a system that will govern all conduct or explain that which has been unexplainable. But such efforts are always shown to be insufficient, thus modifications, then more modifications, are issued. The result is chaos due to endless distinctions and exceptions.

Just as separate waters flow downhill toward a common pool, only a return to the Way restores harmony among people.

33

Understanding what other people want and how they get it is important, but understanding the same in yourself is a precondition to following the Way.

Managing others is commonly thought of as the most difficult of endeavors, but managing yourself is much more arduous.

Those who have placed no limits on their cravings can never relax, and the glory of contentment will always elude them. Those who have found the level at which they are content can cease struggling; to others they appear as if asleep, but they know peace and they endure.

34

The Way, being silent but nourishing, and having no need for recognition, flows in both the ordinary and the obscure. It does not demand, yet all obey, even though they do not know they have a ruler.

A fit person emulates the Way and thus achieves greatness.

35

When you are at one with the Way, others can see that; they sense peace and safety. Do not make the mistake of believing that words are a substitute for what people need to see.

Unlike music, which draws the curious, or good cooking, which draws the hungry, words alone will sound flat and leave a dull taste. The fit understand that words fail because the Way has too light a touch to be clearly described.

Though the Way can be relied upon without limit, before people are convinced of that they need to experience how you, and not merely your words, are enhanced by it.

36

Expansion ends when over-extension occurs.
Power ends when the powerful abuse their power.
Wealth ends when the wealthy become decadent.

As awareness of a repugnant thing increases,
so does resistance to it. This explains how the
weak, through patience, overcome the strong and
how oppressors and those who envy them trade
places. It also explains the survival of those who do
not cause awareness and resistance through control,
coercion or overindulgence.

37

Be like the Way and practice non-interference. Wait for others to seek a remedy rather than forcing it upon them, and offer assistance only when the solution has been spontaneously developed by circumstances.

If those who have control would practice non-interference, everyone would eventually slip into the spontaneous flow of things. People might initially resist this approach as inept, but as they learned to cease craving and trust in the Way, they would find contentment.

38

A fit person possesses virtues that do not appear to be virtues because they are spontaneous and instinctive; accomplishes everything as well as anyone can expect; does not try to control and thereby allows everything to take its natural course; is truly kind and therefore useful to others.

An unfit person makes a show of having virtues; substitutes activity for effectiveness; meddles in others' affairs and causes discord; substitutes justice and force for caring, leaving bitterness.

The road to anarchy is thus traveled step-wise: first, false virtues; then unsolicited interference; then justice and force. Rituals, admonitions to follow the old ways and demands for loyalty represent the final stage.

A fit person is grounded in the way things really are and is not deceived by the way others or their institutions would have them appear, just as one plucks the fruit and is not distracted by the flower.

39

The fit who preceded us saw linkage and thus wholeness reflected in the sparkling firmament, the bountiful earth, fit intellects, fertile valleys, myriad creatures, model leaders. They understood that when any of these parts fail, things are thrown out of balance.

Model leaders serve as an example. They have always grown out of the masses of the humble and lowly, just as things grow out of a root; this is why such leaders call themselves unworthy. But when a leader becomes vain and the root is forgotten, the give and take that is necessary between the leader and the led is broken, just as separated wagon parts are no longer a wagon.

A fit person understands linkage thus never forgets the root, even in the face of flattery or rejection.

40

The Way can be described by two characteristics:

First, motion in the form of a return of all things that are, to the condition where they are not–the return to their source;

Second, the function of yielding.

41

A person of potential, when informed of the Way, looks to it for guidance. An ordinary person, when informed of the Way, does not trust it completely. A fool, when informed of the Way, treats it as a joke—and if a fool thought otherwise the Way would in fact be a joke.

Speaking of those who did not understand, the ancients said the following. To them, a lighted path is still not bright enough. To them, accomplishing is mistakenly viewed as withdrawing. To them, the art of flowing with the way things are seems ineffective. To them, the effort that would be needed to lead a virtuous life does not hold the prospect of an adequate payback. To them, the symmetry of a perfect system goes unrecognized. To them, true honesty seems changeable. To them, observation provides no lessons.

The Way is winding in its course, noiseless in its method and murky in its outline, but it is that by which things must be started and completed.

42

The Way presents itself as an interaction of forces called Yin and Yang, and the result is perfect balance. Misery arises when a person acknowledges only one force, for the Way eventually restores balance via the counterforce.

This is an example of how the Way balances things. People abhor being called lonely, dirt-poor and unattended, and strive for the opposite, yet leaders choose such descriptions so that their followers will feel a kinship with them. Thus, the Way can add what is needed by removing obstacles, and it can lessen what is unwanted by adding advantages.

I teach what, from ancient times, has been thought to be most basic: forcing is balanced by resistance; violence is balanced by retribution.

43

The weak overcome the strong in the same way soft things over time become incorporated into harder things–by lacking that which causes resistance.

Few people understand the freedom from resistance that is gained by teaching through example and not words, nor the value of acting without the appearance of acting.

44

Which do you prize more highly, people's impressions of you or who you really are? Those who have found contentment do not fear humiliation.

What is more valuable to you, riches or the things you have that riches cannot buy? Riches eventually disappear either through neglect or theft.

When are you more likely to be discontented, in victory or in defeat? Those who practice moderation thrive; they avoid the repercussions that victory and defeat bring.

45

The Way, though perfect and inexhaustible, will sometimes appear to offer nothing.

When the right solution finally appears, it may at first seem inappropriate. The most direct route may look like a meandering path; the greatest insight may seem balmy; the most effective explanation may sound unpolished.

Have patience and never undertake action just for the sake of action. Simply wait quietly for the solution that will bring only the right results, then use that solution even if it appears unorthodox. Clarity and serenity should be at the root of all action.

46

When people follow the Way they are unselfish, productive, caring and able to enhance both their lives and the lives of others. When people lose the Way they are selfish, self-destructive, combative and breed misery for themselves and others.

Surrendering to cravings breeds selfishness, which takes you as far from the Way as is possible and leads to the ultimate misery: a life of discontent. It is a tragedy to be ignorant of the need to stop acquiring and controlling.

You will not settle for anything less once you know contentment achieved through release from cravings.

47

There is a way of knowing that is independent of travel. Travel can even result in misinformation if the traveler is not perceptive.

Without leaving home a person can learn the Way. Such a person will not have seen everything a traveler has seen yet has a profound understanding of the things that have been observed, of the way things really are, and of the way things change.

A fit person achieves without striving.

48

Ordinary learning involves the daily accumulation of things that obscure the Way. Learning the Way involves the daily elimination of artfulness, artifice, manipulation and other practices that interfere with a life of being effective without controlling and acting without seeming to act.

Anything is possible when one does not strive.

49

A fit person abandons self and in so doing merges with all the world: good to both the good and the bad, because that is the genuine exercise of the virtue of goodness; believing in people who merit belief and those who do not, because that is the genuine exercise of the virtue of trust.

By doing these things for the world a fit person acts as a mentor, and allows others to perceive the Way.

50

Some try to put death out of mind by pursuing the easy life. Some dwell morosely on death and try to devise strategies to defeat it. Some just muddle through life, feeling uneasy about its end, yet powerless.

The fit person has abandoned self and knows the world as home, accepting whatever it offers. Such a person does not fear death nor anything else.

51

All things come into being with the Way naturally inbred; it then nurtures, develops and protects them. In people, the Way is retained and grows in awareness through the practice of the virtues.

Unseen power is vested in those who nurture but then let go; who are caring but do not seek to be honored for accomplishments; who help others but not with the expectation of designing their lives.

52

The Way is the mother of everything and to the extent you know the Way you then know the things of the world, which are its children. Conversely, those who know the children then understand more fully the mother. Children who seek the protection of their mother sidestep trouble.

Trouble diminishes to the extent you are not judgmental and aim for a simple life. Trouble increases to the extent you insert yourself into the concerns of others and add complexity to your life. Perception is achieved by taking notice of insignificant things. Strength is attained by remaining flexible.

Use such knowledge to enhance your recognition of the Way, and thus avoid trouble.

53

Even those with little tutoring in the Way can find the correct path if they wish; the real problem is the seemingly irresistible distractions that cause deviations from the path.

Deviations from the path include arbitrary or excessive use of power against the powerless; wealth which comes at the expense of those who have no choice but to submit; pretentiousness; drunkenness and gluttony; not knowing when enough is enough. Each of these selfish acts represents a form of theft, as each directly diminishes the lives of others.

When you notice something is out of balance, you can be certain someone has strayed from the Way.

54

When a person has mastered the virtues, the Way will not be abandoned nor dislodged.

Succeeding generations will celebrate and revere the fit person, whose good example spreads through the family; whose good example spreads through the community; whose good example spreads through the country; whose good example spreads through the world.

How do I know this to be correct? This advice represents my experience.

55

The possessor of virtue is like a newborn, in that a newborn epitomizes harmony: it can cry for long periods and not grow hoarse; its frame is weak but its grip is strong.

To be in harmony with everything is to be stable; when you achieve stability you can then see things as they are.

Harmony, and hence stability, are lost when matters are forced. Let things develop at their own pace and you will not be disillusioned, nor will you be worn down by friction.

56

If you have understanding you need not argue or interfere; if you do not have understanding you must not argue or interfere. Do not attract attention through discord. Accept change as inevitable. Eliminate from your life all things that are nonessential. Downplay your intelligence and blend into the background.

The result is insight produced by the quieting of your mind and senses, and a release from the push and pull of abhorrence or affection, loss or gain, condemnation or acclaim.

57

Integrity and the intelligent application of rules are necessary qualities of one who governs a country. Ingenuity and flexibility are required of one who leads an army. But to be a leader of humanity you must go to another level and learn to let things take their course.

How do I know these things? As you pile rule upon rule people become poorer, less honest, less predictable, better armed and more prone to trickery and thievery. The usual reaction of leaders is to then use force.

A fit leader knows what to overlook and understands the insufficiency of laws. Let people work out their problems using their natural talents. Practice restraint and people will arrange matters so that evasion is replaced by productivity. Minimize the urge to control people and they will not need to be devious.

58

The more a government restrains itself the happier people are because they know that intrusion into their affairs inevitably brings poverty, which generates resistance, which triggers repression. When law follows law, what is declared good one day is bad the next and the innocent become lawbreakers. Then leaders wonder why people do not comprehend their plans.

The fit know that good and bad each contain the seed of the other and that even the most well-intentioned plans may fail because unpredictability is built into life. They also know that rules turn back upon their maker; that being righteous does not mean one understands what is right for others; that the best plan permits things to evolve spontaneously.

59

Whether as a leader or a follower, being at one with the Way is the result of yielding, and yielding is the result of having a reserve of long-practiced virtues. Such a reserve is best acquired by learning virtues at an early age.

When virtues are rooted so deep in your character that you spontaneously apply them, you naturally yield, whereupon the impossible becomes possible.

60

Lead a country using a light touch, just as you might prepare small fish.

Evil is certainly present in the world, but a country that is lead by a fit person exercising restraint is no longer a place of fear and apprehension. Because the leader and the people are united, evil cannot get a foothold.

61

A river rests lower than the hills and thereby fills itself. The hills lay higher than the river but yield to the river and are thereby emptied. Each benefits the other. So too, the female quietly attracts the male, who yields to the female. Each benefits the other.

If those who are powerful wish to extend their power, they must first attend to the needs of the less powerful. On the other hand, the powerless, if they wish to deal successfully with the powerful, must first render homage.

Both the powerful and the powerless may have legitimate concerns, and for each to be satisfied the powerful must first offer some benefit to the powerless.

62

The Way has something for everyone: to a fit person it offers more than wealth can supply; to a person who is lost it offers the prospect of finding what that person knows is missing.

You may impress a person who is lost through the clever use of words or the promise of riches, but only a life lived in accordance with the Way is a gift worth giving to that person. Teach that person the Way by being a living example of contentment.

The ancients realized that those who follow the Way are fulfilled, and that those who know they are not fulfilled can find everything they need in the Way. This is why it was said that the Way is the most valued thing in existence.

63

Apply the virtue of non-striving by first giving due thought to the matter under consideration and the need to always reply to hatred with goodness; then use the least effort possible, so that when you act it is without seeming to act.

Accomplish non-striving and greatness through small acts. Whether you are creating or preventing, small actions collectively have profound effects, especially at the beginning. Do not ignore them; rather, regard them as most important, and in this way achieve much and avoid trouble later. Every complicated situation began as a collection of insignificant actions.

You will need to be flexible, so keep this in mind when asked to make a promise, even if it seems small and unimportant at the time.

If you realize the significance of trivial acts, you avoid trouble.

64

With only a little watchfulness, a situation that is not a problem need never become a problem. With little effort, weak things can be broken and small things can be diffused. Act when an insignificant effort can eliminate a difficulty and do not wait until the situation has become unmanageable.

Note how a large tree emerges from a single seed; how a tall tower arises from the simple act of laying brick upon brick; how a long journey begins with a single step. By the simple practice of attending to small things you eliminate the need for later grasping and intervention, and affect the end as much as the start.

The fit person, by avoiding cravings and extremes and wanting only simple, easily acquired things, teaches others how to return to the Way and creates the conditions for the natural and spontaneous elaboration of all things.

65

The ancients who understood the Way knew the limits of language, the wonders of good example and the dangers associated with the mere collection of facts. They knew that the accumulation of facts without the means to place them in perspective creates fools who cause trouble for themselves and everyone else.

Understanding the difference between wisdom and the mere accumulation of facts, and applying that understanding, is one of the virtues, and is fundamental to perceiving the Way.

66

Water naturally moves to the lowest level, from where it silently grows to become great.

The fit person who wishes to lead others must also be lowly and humble, both in manner and speech, so that others do not feel bothered. Such a person can thus lead without leadership being recognized, and when others find to their delight that they have benefited, true leadership will be appreciated.

People will not push back when the fit person gives them nothing to push against.

67

People say that the Way may be fine, but that it is not the normal way of people. But it is because it is not the normal way of people that it is the Way.

I treasure three qualities associated with the Way of daily affairs; note how they differ from the normal way of people.

I try to care for every person and every thing. The more I care, the less I fear, because I no longer think about myself so much. Caring brings victory against opponents and defense against attacks, and is the instrument through which the Way protects.

I try to be simple and unpretentious in speech, deed and material matters, which enables me, without resistance, to share my beliefs and possessions with others for whom I care.

I try not to force myself into others' affairs and do not attempt to control them, unlike the determined and ambitious who have no such reluctance. I can then do what I do without contention.

68

Even among warriors, the best do not recklessly seek a confrontation, and suppress the urge to vent the emotions.

The fit consistently excel by being modest and unassuming. They maneuver gracefully, in a non-confrontational manner, in order to avoid showdowns and minimize resistance.

Non-contention is the virtue that permits a fit person to tactfully manage matters, and to the ancients it was considered the secret of union with all that is natural.

69

Those ancients who were in charge of defending their country advised that one should avoid a battle unless there is no other recourse. There was awareness that, through subtlety, an army can often obtain what it wants without the grave risks associated with open conflict.

They understood that conflict is often prompted by someone who has misjudged the opponent, because it is difficult to properly evaluate and easy to underrate an opponent. Not appreciating strength is as disastrous as loosing the virtue of caring and the protection it provides.

So, when force must be used the winner will be the party who best tried all other reasonable means to avoid conflict, because that party did not make the fatal mistake of misjudging its opponent.

70

What I say and do can be duplicated by others but few do so. My advice is derived from the ancients and my deeds are in accord with the Way, but few understand the Way and therefore I remain a mystery.

A fit person should just remain patient and not expect anything; if and when someone is ready for the Way, that person will know where to look.

71

The fit know when they have reached the limits of understanding. Others overrate their own knowledge, some to the extent that they think they have all the answers.

The fit are different because they can accept the state of not-knowing.

72

Ignorance of how power is acquired and then used against people is the common thread running through the lives of the powerless. Leaders take advantage of this ignorance and make life stressful for the powerless who, in turn, make life stressful for the leader.

A fit person can open minds and lead both the powerful and the powerless out of the cycles to which they are wedded, but this must be done humbly and without boasting.

73

Death is the outcome for the brave who exhibit their boldness, and life is the payoff for those who practice the art of the subtle. The first can lead either to a quick victory or a meaningless sacrifice; the second can lead to an eventual victory without the need for confrontation, or an extended waste of effort.

Choosing the right course at the right time can be a challenge, because the Way does not struggle yet prevails; is silent as it patiently attains its objectives; does not flaunt its methods; represents the perfect arrangement of things and sweeps everything into its net while concealing its intent.

74

Every leader should realize that there is no effective strategy for dealing with people who would gladly face death to be rid of their leader. But even if a death sentence would spread fear and thereafter act as a deterrent, how can it be known for certain that one's understanding of the Way is sufficient to support the taking of a life in order to dissuade others from such an action?

Granted, being born into the world means death will follow, but to intervene in this natural process is like displacing a master carpenter: a novice is likely to damage a hand if the master's methods are not completely understood.

75

Leaders who demand too much, or interfere too much, empty the storehouse of vitality of those who are led, leaving mere husks with incentive to make trouble and with nothing to lose.

For their own benefit, leaders must do what is best for those who are governed, for the governed understand that every leader craves safety and is vulnerable to the more worthy person who does not.

76

Things come into the world flexible and yielding and when they leave are inflexible and unyielding. From plant to person to army, when a thing becomes inflexible its end is at hand.

Notice how a tree of the hardest wood will either be selected as the cutter's first choice, or, unable to bend in the wind, will be replaced by another that is supple.

The inflexible and unyielding give way to the flexible and yielding.

77

The counterpoise of a drawn bow is a reflection of the Way, which keeps everything in balance by raising the lowly, lowering the lofty, enhancing that which is lacking and reducing abundance.

Those not in accord with the Way could, by their acts, imitate the symmetry of the drawn bow. Instead, they contribute to imbalance, taking the few things the powerless and poor have and enhancing the power and wealth of those who already enjoy those privileges.

Through generosity, those in accord with the Way can counter imbalances, even if the only thing they possess that can be shared with others is their understanding of the Way. In so doing, remember that the power to restore balance will be impaired to the extent you disclose your efforts or expect appreciation.

78

Water is the most benign and yielding of all substances, yet over time, and without itself being corrupted, it wears down everything that blocks its path because it is relentless.

Like water, the flexible and yielding overcome the inflexible and unyielding. This idea comes as no surprise to people, yet they lack experience in applying it, so that they are puzzled when the fit person advises, "One who always assumes responsibility for failures while trying again and again to do the right thing will eventually succeed, and is the ideal leader."

Fundamental things are invariably the most difficult to comprehend.

79

Among ordinary people, great differences of opinion may appear to be settled, but they are never fully reconciled.

The fit avoid quarrels, try to correct their faults, and attend to their duties, so as to be better able to serve others. They thus become more virtuous, while quarrelers do nothing but cling to their quarrels.

The Way prefers no one; the fit simply know how to ignore detours and find it.

80

A small community has these advantages:

Because its leaders live with and have to account to the inhabitants, they know enough to avoid rules that interfere in people's affairs but bring no benefits.

The people are wary of laborsaving devices due to the eventual turmoil and complications they bring. They understand the perils of travel and aggression, thus, though they have the means, they find no reason to leave even though they can hear the bustle from another locale.

Everyone cherishes ordinary food, traditional clothes and safe homes. They enjoy their customs and live plainly.

81

If you tell a person what that person does not want to hear, you create resistance, but if you tell that person what that person wants to hear, you might ratify a lie.

Knowing this, a fit person only teaches by example, for prudence involves more than the objective collection and presentation of facts. The foolish rely upon words, and will either offend or shade the truth; either way, they will prove nothing.

The fit person finds it unnecessary to collect things or withhold what is valuable to others, because the more that is given to others the more they support your needs.

The Way nourishes everything by merely being available for use. The fit person cares for everything by merely acting as a model.

ADDITIONAL TITLES FROM HOHM PRESS

CRAZY AS WE ARE
Selected Rubais from the Divan-i-Kebir of Mevlana Celaleddin Rumi

Introduction and Translation by Dr. Nevit O. Ergin

This book is a collection of 128 previously untranslated *rubais*, or
quatrains (four-line poems which express one complete idea), of the
13th-century scholar and mystic poet Rumi. Filled with the passion of
both ecstasy and pain, Rumi's words may stir remembrance and
longing, or challenge complacency in the presence of awesome love.
Ergin's translations (directly from Farsi, the language in which Rumi
wrote) are fresh and highly sensitive, reflecting his own resonance with
the path of annihilation in the Divine as taught by the great Sufi
masters.

Paper, 88 pages, $9.00 ISBN 0-934252-30-0

• • •

THE JUMP INTO LIFE: Moving Beyond Fear
by Arnaud Desjardins
Foreword by Richard Moss, M.D.

"Say Yes to life," the author continually invites in this welcome guidebook
to the spiritual path. For anyone who has ever felt oppressed by the life-
negative seriousness of religion, this book is a timely antidote. In language
that translates the complex to the obvious, Desjardins applies his simple
teaching of happiness and gratitude to a broad range of weighty topics,
including sexuality and intimate relationships, structuring an inner life,
the relief of suffering, and overcoming fear.

Paper, 216 pages, $12.95 ISBN: 0-934252-42-4

**TO ORDER PLEASE SEE ACCOMPANYING ORDER FORM
OR CALL 1-800-381-2700 TO PLACE YOUR ORDER NOW.**

ADDITIONAL TITLES FROM HOHM PRESS

RENDING THE VEIL: Literal and Poetic Translations of Rumi
by Shahram T. Shiva Preface by Peter Lamborn Wilson

With a groundbreaking transliteration, English-speaking lovers of Rumi's poetry will have the opportunity to "read" his verse aloud, observing the rhythm, the repetition, and the rhyme that Rumi himself used over 800 years ago. Offers the reader a hand at the magical art of translation, providing a unique word-by-word literal translation from which to compose one's own variations. Together with exquisitely-rendered Persian calligraphy of 252 of Rumi's quatrains (many previously untranslated), Mr. Shiva presents his own poetic English version of each piece. From his study of more than 2000 of Rumi's short poems, the translator presents a faithful cross-section of the poet's many moods, from fierce passion to silent adoration.

"Faithfully polished translations." – *Publisher's Weekly*

Cloth, 280 pages, $27.95 ISBN: 0-934252-46-7

• • •

THE WAY OF POWER
by RedHawk

Nominated for the 1996 Pulitzer Prize in Literature, RedHawk's poetry cuts close to the bone whether he is telling humorous tales or indicting the status-quo throughout the culture. "This is such a strong book. RedHawk is like Whitman: he says what he sees..." William Packard, editor, *New York Quarterly.*

Paper, 96 pages, $10.00 ISBN: 0-934252-64-5

**TO ORDER PLEASE SEE ACCOMPANYING ORDER FORM
OR CALL 1-800-381-2700 TO PLACE YOUR ORDER NOW.**

ADDITIONAL TITLES FROM HOHM PRESS

TAO TE CHING FOR THE WEST
by Richard Degen

A new rendition of the revered classic, *Tao Te Ching,* this sensitive version offers a contemporary application of Eastern wisdom to the problems created by modern Western living.

Paper, 120 pages, $9.95 ISBN: 0-934252-92-0

• • •

FOR LOVE OF THE DARK ONE: SONGS OF MIRABAI
Revised edition
Translations and Introduction by Andrew Schelling

Mirabai is probably the best known poet in India today, even though she lived 400 years ago (1498-1593). Her poems are ecstatic declarations of surrender to and praise of Krishna, whom she lovingly calls "The Dark One." Mira's poetry is as alive today as it was in the sixteenth century—a poetry of freedom, of breaking with traditional stereotypes, of trusting completely in the benediction of God. It is also some of the most exalted mystical poetry in all of world literature, expressing her complete surrender to the Divine, her longing, and her madness in love. This revised edition contains the original 80 poems, a completely revised Introduction, updated glossary, bibliography and discography, and additional Sanskrit notations.

Paper, 128 pages, $12.00 ISBN: 0-934252-84-X

**TO ORDER PLEASE SEE ACCOMPANYING ORDER FORM
OR CALL 1-800-381-2700 TO PLACE YOUR ORDER NOW.**

GRACE AND MERCY IN HER WILD HAIR
Selected Poems to the Mother Goddess
by Ramprasad Sen; Translated by Leonard Nathan and Clinton Seely

Ramprasad Sen, a great devotee of the Mother Goddess, composed these passionate poems in 18th-century Bengal, India. His lyrics are songs of praise or sorrowful laments addressed to the great goddesses Kali and Tara, guardians of the cycles of birth and death.

Paper, 120 pages, $12.00 ISBN 0-934252-94-7

• • •

THE ART OF DYING
by RedHawk

In this collection of 90 new poems, RedHawk scrutinizes a range of vital subjects from children, nature and family, to God, politics and death. "An eye-opener; spiritual, native, populist. RedHawk's is a powerful, wise, and down-home voice."

Paper, 120 pages, $12.00 ISBN: 0-934252-93-9

RETAIL ORDER FORM FOR HOHM PRESS BOOKS

Name_____ Phone (___) _____

Street Address or P.O. Box _____

City _____ State _____ Zip Code _____

	QTY	TITLE	ITEM PRICE	TOTAL PRICE	
	1	**CRAZY AS WE ARE**	$9.95		
	2	**FOR LOVE OF THE DARK ONE**	$12.00		
	3	**GRACE AND MERCY IN HER WILD HAIR**	$12.00		
	4	**RENDING THE VEIL**	$27.95		
	5	**TAO TE CHING FOR THE WEST**	$9.95		
	6	**THE ART OF DYING**	$12.00		
	7	**THE JUMP INTO LIFE**	$12.95		
	8	**THE WAY OF POWER**	$10.00		

SURFACE SHIPPING CHARGES

1st book .. $4.00

Each additional item $1.00

SUBTOTAL:	
SHIPPING: (see below)	
TOTAL:	

SHIP MY ORDER

☐ Surface U.S. Mail—Priority ☐ UPS (Mail + $2.00)

☐ 2nd-Day Air (Mail + $5.00) ☐ Next-Day Air (Mail + $15.00)

METHOD OF PAYMENT:

☐ Check or M.O. Payable to Hohm Press,

 P.O. Box 2501, Prescott, AZ 86302

☐ Call 1-800-381-2700 to place your credit card order

☐ Or call 1-520-717-1779 to fax your credit card order

☐ Information for Visa/MasterCard order only:

Card #_____–_____–_____–_____

Expiration Date_____

Visit our Website to view our complete catalog: www.hohmpress.com

ORDER NOW! Call 1-800-381-2700 or fax your order to 1-520-717-1779.

(Remember to include your credit card information.)